Flying the Nest

Flying the Nest

The early days of Britain's best-loved animals

Hannah Dale

BATSFORD

For Mum and Dad, I love you both

First published in the United Kingdom in 2015 by
National Trust Books

This edition first published in 2016 by Batsford
1 Gower Street, London WC1E 6HD

An imprint of Pavilion Books Group Ltd

Copyright © Batsford, 2015

Text and images © Hannah Dale, Wrendale Designs 2015

The moral rights of the author have been asserted.

ISBN: 9781909881556

A CIP catalogue record for this book is available from
the British Library.

10 9 8 7 6 5 4 3 2

Reproduction by Mission Productions, Hong Kong

Printed and bound by Toppan Leefung Printing Ltd, China

This book can be ordered direct from the publisher at the website
www.pavilionbooks.com, or try your local bookshop.

Contents

Introduction

When asked to write and illustrate a book about baby animals, I have to say that I was daunted by the task ahead. There is no denying the 'cute' factor – it's striking how appealing baby animals of all species are – and during the process of researching the book, I came across a few that even surprised me with their unutterable gorgeousness. Who could possibly resist the peacock chick with his stubby little tail, displaying it with all the pride of the bejewelled adult male showing off his eccentric tail feathers? Not to mention the sweet little 'puffling' (doesn't the name just say it all?), fluffy and adorable even without the striking multicoloured beak of the adult puffin. However, for me, therein lies the challenge. I always seem to be drawn to life's stragglers. The runt of the litter, the scruffy mongrel, the weathered-looking hare who has seen his share of 'mad Marches' and boxing fights. I always try to paint a character rather than just an image. By the end of the painting, we are old friends and I have conjured up a whole life story for him or her. I was, therefore, unsure how to tackle a subject almost defined by its sweetness – it's just not me!

I needn't have worried. It's impossible to get away from the fact that baby animals are cute, and in the end, I embraced this. After all, life is often tough for newly born wildlife, and this was a recurring theme as I researched the book. Take, for example, the leveret. With

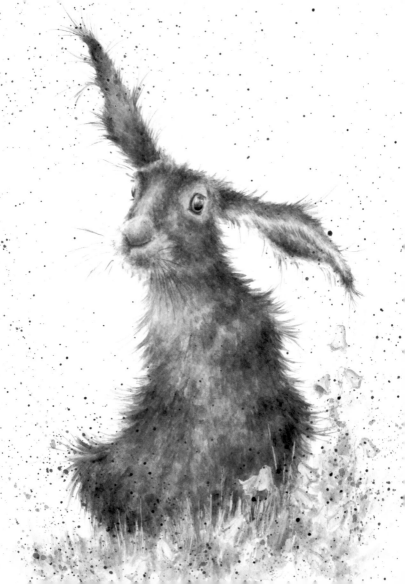

its ears pinned back, crouched into its nest – a hollow scraped into the open ground – the first challenge the young hare faces is to survive its first week. Baby hares are often mistaken for having been abandoned, but in fact, the mother's rich milk can sustain her young all day, meaning that she has to make fewer visits, therefore reducing the risk of attracting the unwanted attentions of predators on the lookout for their next meal. It was fascinating to learn how the appearance of so many juvenile animals is shaped by the fight for survival as well, often resulting in them looking very different from their parents. The common tern chick, its dappled down providing it with the perfect camouflage, is unrecognisable from its graceful parents with their striking black and white plumage and forked tails. I also found plenty of examples to satisfy my craving for the odd-looking and obscure. Particular favourites are the grey heron with its wild hair and oversized beak, and the moorhen, tumbling over its enormous feet – perfect for navigating weeds and lily pads on the surface of ponds.

It was also fascinating to learn more about the darker side lurking behind the unassuming exterior of Britain's animal babies. I spent some time after university as a research assistant, and one project I helped on was the study of brood parasitism in meadow pipits. This entailed day after day of systematically hunting through waist-high heather in the stunningly beautiful Scottish highlands in search of ground-nesting meadow pipits whose nests had been hijacked by the most notorious of all birds, the cuckoo. Its first act as a newly

hatched chick is to swiftly dispatch its adoptive siblings, ensuring the poor parents give all of their attention to this insatiable and demanding bird. Evolution has shaped all aspects of the cuckoo's appearance and behaviour, and indeed that of all other species, in an ongoing battle for survival. This has resulted in a rich variety of intriguing life histories amongst the inhabitants of the British countryside, and it has been an absorbing journey researching and learning about some of them.

With this book, I have tried to offer a glimpse into the fascinating world of the wild and domestic animals we share our lives with and I hope that the illustrations serve to capture some of the eccentric and charming personalities of these wonderful characters. Above all, I hope it inspires you to celebrate the wonderful variety of life in the great British countryside.

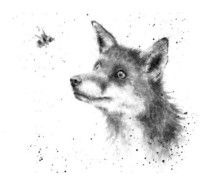

Woodland

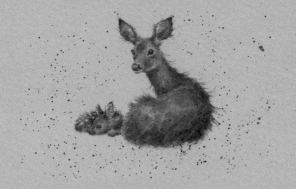

Tawny Owl
Strix aluco

Beautiful brown-eyed tawny owls find a partner at one year of age and will usually mate for life, hooting and calling to one another as part of their courtship. They nest in holes in hollow trees and will produce between two and four glossy white eggs in each clutch. The eggs hatch 28 days later and the chicks will stay in the nest for a further month, curiosity eventually getting the better of the young owlets as they start to hop out onto nearby branches. The demanding fledglings spend most of their time calling out to their parents and waiting to be fed – they can call all night at five to six second intervals, which would test the nerves of any parent! The owls take care of the young for two to three months, with the devoted dad doing the majority of the feeding. Once the owls have flown the nest, it is vital for them to find a territory of their own.

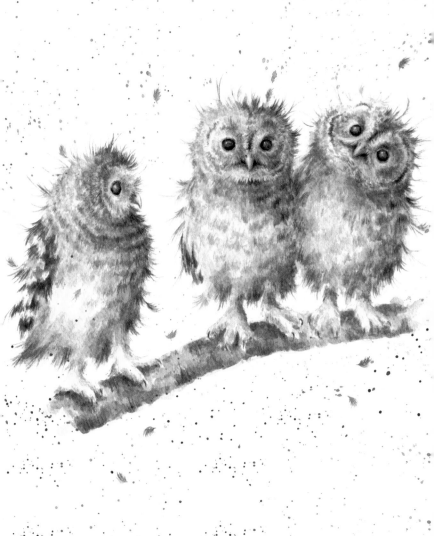

Barn Owl
Tyto alba

Beautiful and ghostly, the barn owl is an old romantic and they will pair up for life once they have found a mate. They build their nests in cavities, with their favourite haunts being old barns and buildings, as the name suggests. They are creatures of habit and will return to established nest sites year after year. The female lays a clutch of white, oval eggs. The number of eggs laid is determined by the supply of rodents in that particular year, with more rodents meaning more eggs. The barn owl starts incubating after the first egg is laid, so the chicks hatch at intervals and the siblings therefore vary in age and size. In a touching act of filial generosity, barn owl chicks sometimes feed each other, which is very unusual in birds.

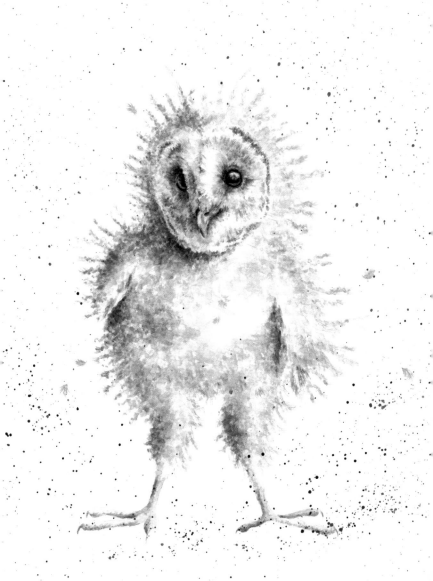

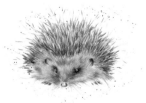

Hedgehog
Erinaceus europaeus

Hedgehog courtship is an awkward affair, entailing much snorting, huffing and puffing, although it's probably understandable considering the prickly issue of the task ahead. The commotion often attracts the attention of rival males, and confrontation is common. In June or July, a litter of four or five hoglets (yes, they really are called hoglets!) are born. They are blind and their soft spines are concealed under a membrane but become visible shortly after birth. Hedgehog mothers tend to be quite nervous and it is not uncommon for her to abandon the young if she is disturbed. Within three to four weeks, the young accompany their mother on foraging trips, and after another ten days, they are ready to go it alone.

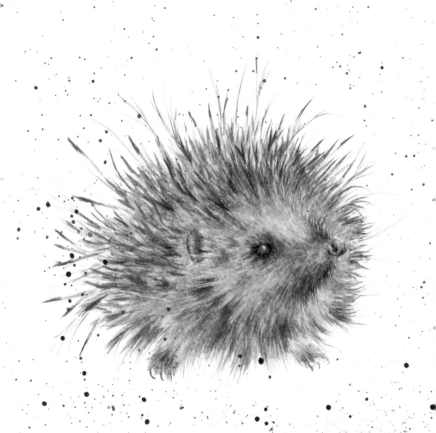

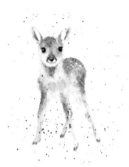

Roe Deer
Capreolus capreolus

The adorable roe fawn was made famous by Felix Salten as the
star of the original story *Bambi, a Life in the Woods* (although
Disney had other ideas and changed Bambi to a white-tailed deer
for the film, as they were more familiar to the American public).
The roe deer is native to Britain, but nearly became extinct by 1800
due to hunting and deforestation. Thankfully, this pretty deer was
reintroduced in Victorian times and is now widespread across the
British Isles. If you ever see odd-looking figure of eight shapes
around trees in woodland areas, you may be mistaken for conjuring
up images of alien space crafts and crop circles but they are in fact
'roe rings' – paths trampled down in the undergrowth as the male
chases the female in circles as part of the courtship ritual.
Twins, and sometimes triplets, arrive in the warmer months of
May and June and the spotted fawn is well camouflaged against the
bracken, brambles and grasses.

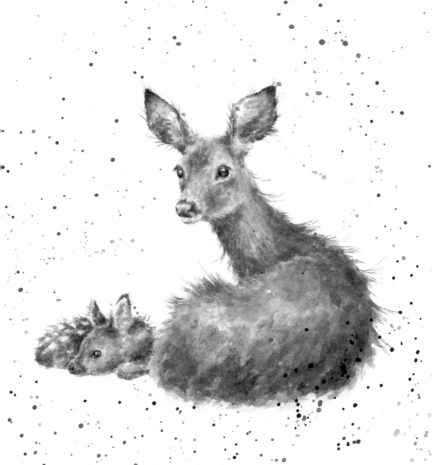

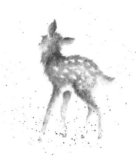

Fallow Deer
Dama dama

One of the prettiest of our resident mammals, the fallow deer comes into existence following a ferocious courtship ritual which takes place around late September. Powerful males strut and stride before one another, demonstrating their prowess in the hope that rivals will back down at the mere sight of them. If this fails, it can end in violent clashes that may inflict fatal blows on the antagonistic males. When the mating season is over, a single fawn is born in June. The female finds a hiding place for her fawn in an area of dense vegetation away from the herd and returns to feed it every four hours or so. After three to four weeks, the fawn and mother rejoin the herd, which consists of other females and their young.

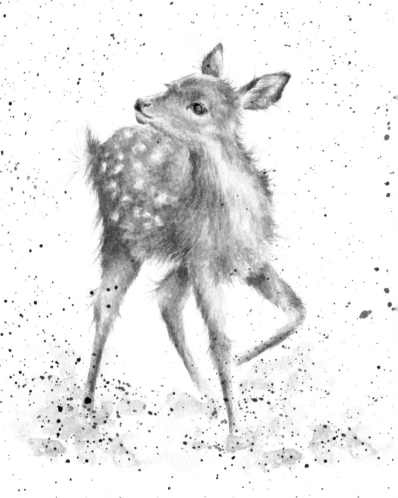

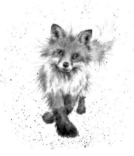

Fox
Vulpes vulpes

Your best chance of seeing foxes in the wild is between May and July when the young emerge from their den, and who can fail to be charmed by the russet-coloured cubs, full of energy and fun? At this time of year they can often be spotted wrestling and play fighting with their brothers and sisters and learning to catch small rodents with their characteristic high pounce. Fox cubs are born blind and deaf in an underground den in March or April, with a litter typically containing four to five cubs. The vixen cares for the young but the male will bring her food right through the winter months and after the cubs are born. The vixen will often get a helping hand from a non-breeding sister, or a cub from a previous litter. This increases the cubs' chance of survival and also gives the helper valuable experience in looking after little ones, so everyone benefits.

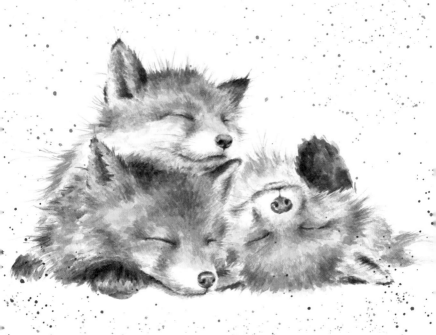

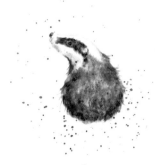

Badger
Meles meles

Badgers have their cubs in the cold month of February. They are born deep underground in their setts, where they stay until April, when they emerge into the daylight with their mother close by. A badger's sett can be very large and complex – the largest known in Britain was 35 metres wide and had up to twelve entrances – with lots of different tunnels and chambers. Badger cubs are silvery grey when they are born, but their characteristic stripes appear after a few days. Their eyes are closed for the first five weeks, their underground existence making it unnecessary to see the world around them until they venture above ground. Badger cubs are very playful animals, play fighting, chasing and climbing with their siblings – all the time developing their coordination and strength, and establishing a hierarchy amongst the family. By twelve weeks they are fully weaned and by fifteen weeks they are able to forage alone. By autumn, the cubs are as large as the adults and spend most of their time eating to build up their fat reserves for the long winter ahead.

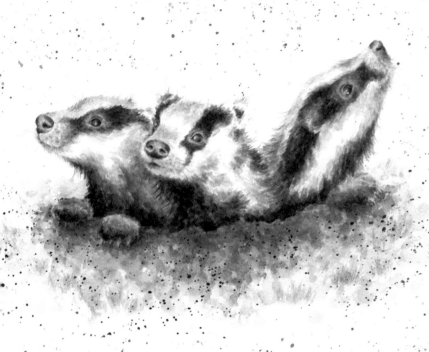

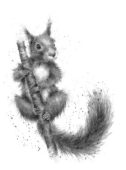

Red Squirrel
Sciurus vulgaris

In certain parts of the country, flashes of russet against the green leaves of an oak tree may well be playful red squirrels chasing one another through the treetops in their brief courting ritual. Red squirrels build large nests, or dreys, in the forks of tree trunks, which they live in all year round, sometimes sharing with relatives to keep warm. They will often build more than one drey in a year, moving on when the fleas become unbearable! When it is time to have their young, the female will build an extra thick drey and line it with grass and hair. The kittens make their appearance in spring and are born blind with no teeth or fur. The female takes sole charge of the young with no help at all from the father. She makes a devoted mother, and if disturbed, will carry the young one at a time in her mouth to a different drey. At seven weeks, the young squirrels are ready to venture out from their nest and begin to explore the world.

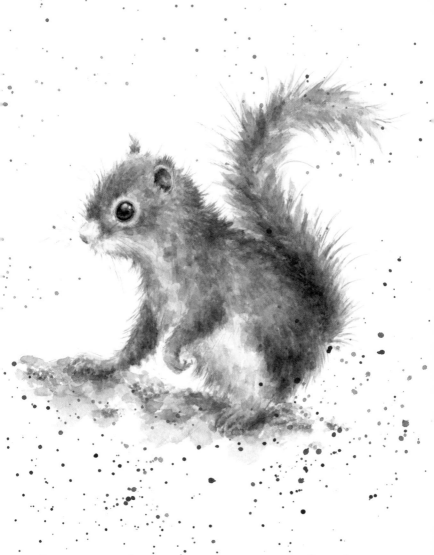

Pheasant
Phasianus colchicus

One of the most striking and yet feather-brained of all British birds, the pheasant is a much-loved symbol of the British countryside. The majority of pheasants in the United Kingdom are bred for hunting. Around 20 million are bred and released every year and, of these, around 40 per cent are shot. Birds that have been born in the wild tend to do much better than the released birds. With the forces of natural selection at work, their genetics, resistance to disease and behavioural differences mean that they have more breeding success than their inbred cousins. In the wild, the female will nest in fields or hedgerow borders and incubates her eggs with no help from the more showy males. The chicks can fly within two weeks and remain with the mother until they are six or seven weeks old.

Wren
Troglodytes troglodytes

The little, mouse-like wren is one of our best-loved birds and is most commonly seen creeping and climbing, seeking out insects with its probing, sharp beak. Its diminutive size is by no means an indicator of the complex personality of this fascinating bird. When it comes to producing its young, the nest building is the role of the male. Not satisfied with just one nest, he builds as many as twelve and then takes prospective mates on a tour around his property portfolio until the fussy female finds one that takes her fancy. She then lines it with leaves, moss and feathers and lays five or six eggs. The little wren lives up to its Latin name, *Troglodytes troglodytes* (meaning 'cave dweller') when it comes to nest building, and the cosy, enclosed nest has a distinctly cave-like feel. The female incubates the eggs but both parents help to feed the young.

Cuckoo
Cuculus canorus

No book about the life history of British wildlife could be complete without a mention of the most wily of them all – the cuckoo. Famous for heralding the arrival of spring with its eponymous call, the cuckoo is even more notorious for its shameless behaviour when it comes to its chicks. Firstly, the mother cuckoo seeks out an unsuspecting pair of nesting birds, busily preparing their nest for the arrival of their own brood. Then, when their backs are turned, the cuckoo removes an egg from the nest and lays one of her own in its place. Remarkably, evolution has shaped the cuckoo's egg to mimic that of the host, making it less likely to be rejected. When the cuckoo chick hatches, its first act as a newborn chick is to eject its foster siblings from the nest. The foster parents then busily feed their one remaining chick as it grows and grows, soon dwarfing them and outgrowing the nest. Despite its despicable behaviour, the cuckoo is an icon of British springtime – and you certainly have to admire its audacity!

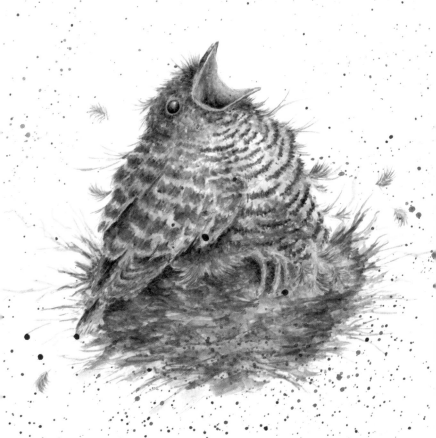

Farmland

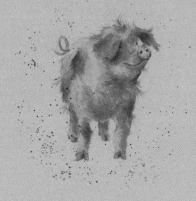

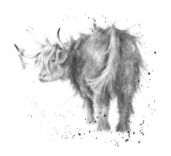

Highland Cow
Bos taurus

Although Highland cattle are famous for their distinctive shaggy, auburn hair and their attractive faces, often hiding behind an oversized fringe, they can actually come in a variety of different colours ranging all the way from black to white. They also have a second coat of 'fluffy' hair underneath, which gives them extra protection against the harsh weather in the Highlands. Known for their gentle nature, they are bred worldwide, but are a much-loved resident of the Scottish countryside, where they originated. Highland cattle make wonderful and devoted mothers, and can be fiercely protective of their calves. The calves are born with a full coat of fluffy hair, making them surely the cutest of baby animals.

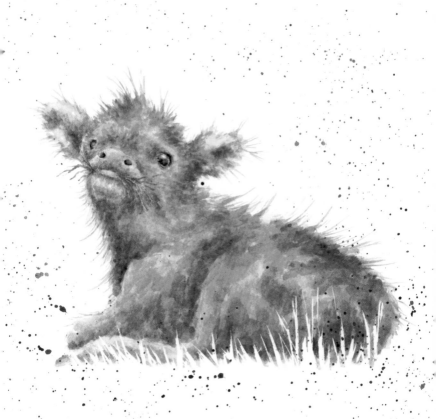

Jersey Cow
Bos taurus

Jerseys are amongst the oldest breeds of dairy cows in the world, and despite the name, their exact origin remains unclear. It is thought that they probably originated in France before making their way to the island of Jersey, from which they take their name. They are a small variety of cattle but what they lack in size, they more than make up for in their delicious, creamy milk, which contains more protein, calcium and butterfat compared to 'average' milk.

Jersey cows are also famous for their beautiful faces, and their calves, predictably, are beautiful too, with large brown eyes framed by long lashes. Jersey cows make excellent mothers, and along with their inquisitive character and docile nature, this makes them a well-loved and popular dairy breed.

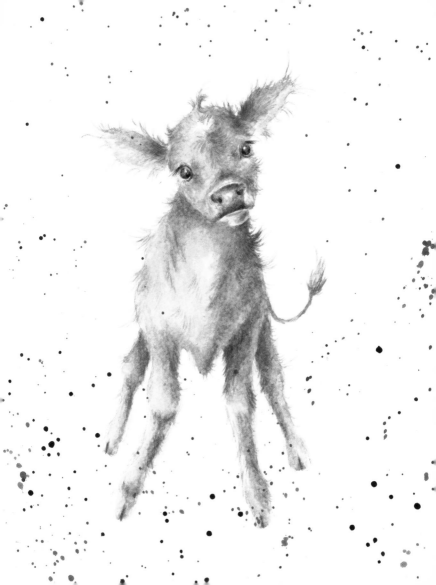

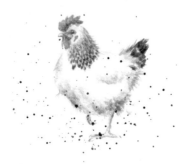

Sussex Chicken
Gallus gallus domesticus

The Sussex is thought to be the oldest chicken bred in Britain,
having originated over here almost 2,000 years ago when the Romans
invaded. Alert, docile and adaptable, it remains one of the most
popular and widely bred chicken breeds in the world. The Sussex
comes in a broad array of colours, including brown, white, speckled,
silver and red, amongst others. It is a prolific egg producer and an
owner of a Sussex hen can expect around 250 creamy brown eggs
a year. The maternal Sussex is often broody in the warmer months
and will make an excellent mother if given the opportunity.

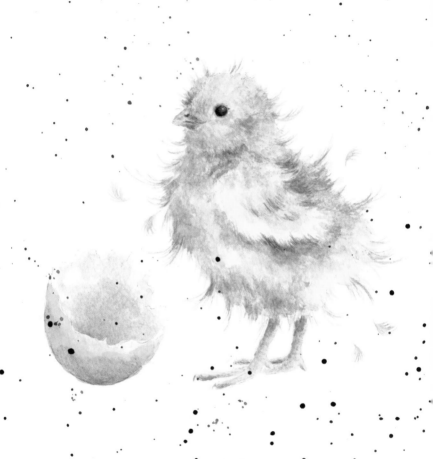

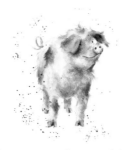

Gloucestershire Old Spot
Sus scrofa domesticus

With its lop ears and distinctive black markings, the Gloucestershire old spot is unmistakeable. Originating on the shore of the River Severn, these pigs were often kept in orchards, grazing on windfall apples and thereby earning themselves the nickname 'the orchard pig'. Legend has it that the black spots are bruises left by falling apples hitting the grazing pigs. Gloucestershire Old Spots are docile and intelligent pigs, and their strong maternal instincts enable them to raise large litters of adorable spotty piglets.

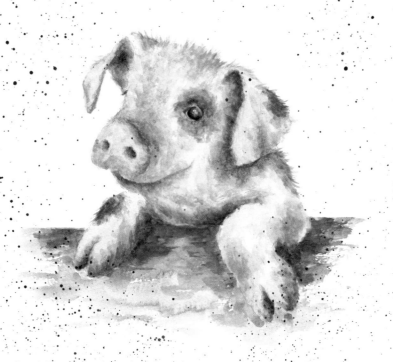

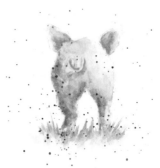

Large White Pig
Sus scrofa domesticus

Large whites are highly intelligent and clean animals, and with almost human-like qualities, there is little wonder that they have inspired some of the most appealing and heart-warming characters in children's literature, such as *The Sheep-Pig* by Dick King Smith (perhaps better known as *Babe*). The breed originated in Yorkshire in the nineteenth century (hence it is also known as the Yorkshire pig) and soon established itself as the 'world's most popular pig' due to its hardy, versatile and gentle characteristics. Large Whites like to build a nest for their young from straw and grass, and give birth most commonly to between eleven and twelve piglets. They make caring and attentive mothers.

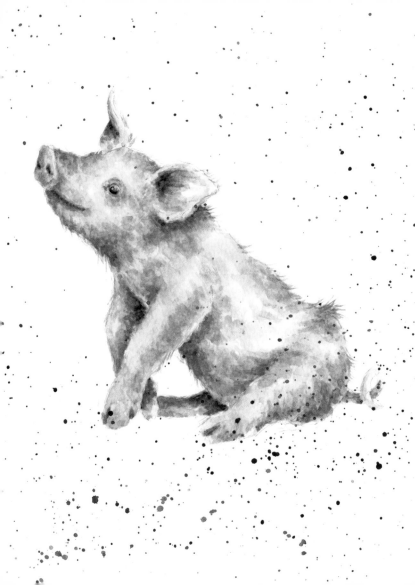

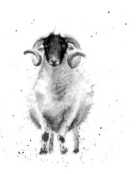

Scottish Blackface Sheep
Ovis aries

The Scottish blackface sheep is by far the most numerous breed in the United Kingdom, making up around 30 per cent of all British sheep. Its main purpose is to enable farmers to make the most of the craggy highlands that provide a hostile environment to most forms of agriculture. Tough and adaptable, with an enviable fleece, the blackface certainly fulfils its role. As well as providing a source of meat, the wool is very high quality and is used to make the famous Harris Tweed fabric. Blackface ewes are very defensive of their young. As both male and females are armed with impressive horns, predators beware!

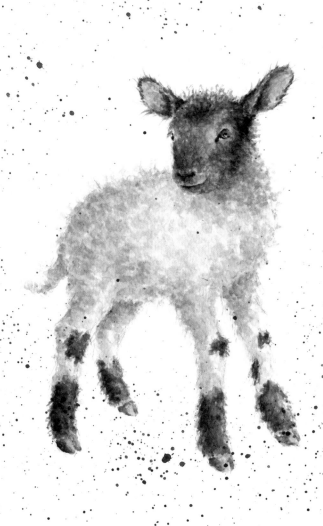

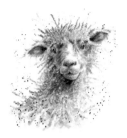

Lincoln Longwool
Ovis aries

The Lincoln Longwool's divine locks are the envy of all their ovine friends. Famous for their curly wool, they produce the heaviest, longest and most luscious fleece of any sheep breed, which can weigh as much as 21kg (your average fleece weighing in at just 6–7kg). Lincoln Longwools have a long history in Britain, and Lincoln was famous for its sheep in the Middle Ages. As agriculture changed in the twentieth century, the Lincolns found themselves on the brink of extinction. They are still considered to be a rare breed, but the dedication of a handful of breeders devoted to these gorgeous sheep ensured their survival, and they are enjoying something of a revival as they are once again appreciated for their curly locks.

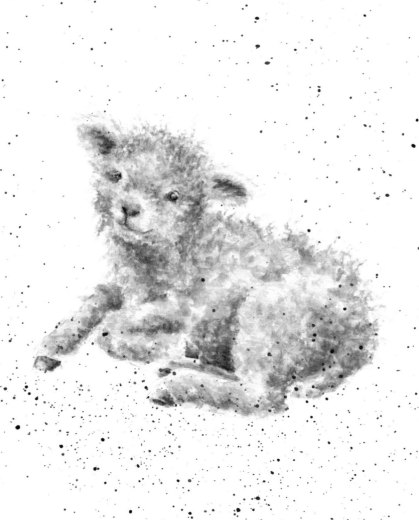

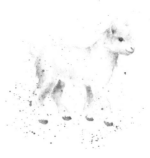

Old British Goat
Capra aegagrus hircus

The Old British Goat has a long history in the British Isles. They are thought to have been introduced by the very first farmers in the United Kingdom. Up to 200 years ago, over a million families kept a 'house goat' which provided invaluable milk, meat, skin, hair and tallow. As agriculture moved on, the goats declined in popularity and were described in the nineteenth century as the 'poor man's cow' – too small, hairy and inconveniently horned for most people's taste – and larger, smoother-coated, hornless foreign breeds were introduced. The Old British would have died out were it not for some escapees that managed to make a living in the wild. Now considered a rare breed, there is growing interest in this little goat, which sustained our ancestors for centuries before falling out of fashion. Wild goats have a 150-day gestation period, after which they tend to produce a single kid, though twins and even triplets are common.

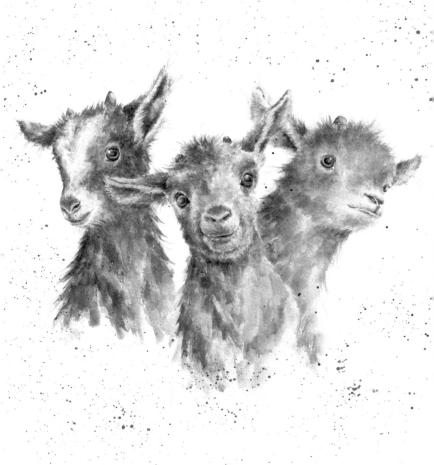

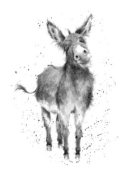

Donkey
Equus africanus asinus

The donkey's association with humans is thought to have begun as long as 5,000 years ago and literature ancient and modern – from the Bible to George Orwell's *Animal Farm* – is littered with references to this humble creature. Notorious for its stubbornness, the donkey is also loved for its gentle nature and soft brown eyes. Female donkeys, known as Jennys, are pregnant for around a year before giving birth to a single foal – twins are uncommon in donkeys. The plucky foal will be standing within an hour and will soon be keen to begin investigating its new surroundings, under the watchful eye of mum. Donkeys make very devoted and protective mothers.

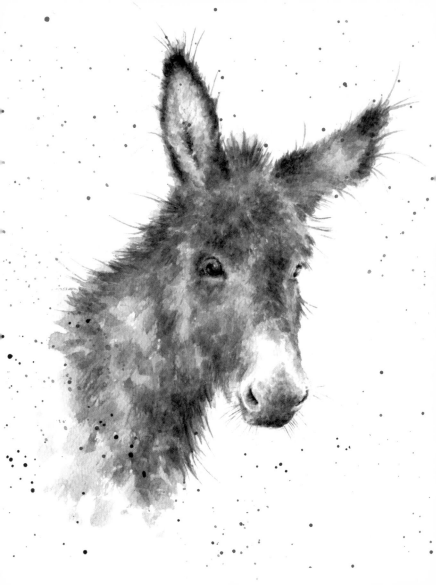

Alpaca
Vicugna pacos

Originally domesticated by the ancient Incas of South America
over 6,000 years ago, alpacas have always been prized for their
luxurious fleece, which was once reserved for wealthy nobility due
to its fine quality, being both waterproof and fire-resistant as well as
warm and soft! Alpacas are now a common sight across the British
Isles, being valued for their friendly and curious nature as well
as their intelligence. They are a herd animal and don't like to be
alone, so make affectionate companions. Alpacas can breed at
any time of year, and produce a single foal, which is up and
walking within an hour of birth.

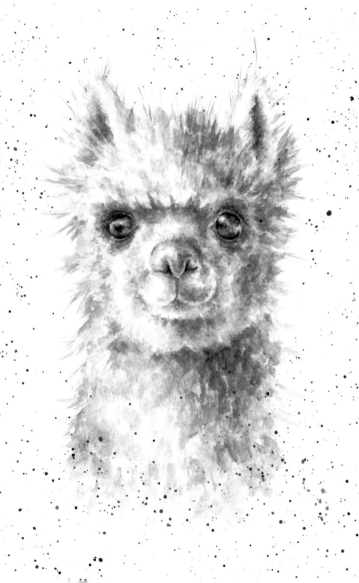

Guinea Fowl
Numididae

With its bony, prehistoric-looking head and speckled plumage, the guinea fowl has to be amongst the quirkiest of birds domesticated in Britain... and certainly the noisiest! With a characteristic screeching call, these birds make noisy neighbours, but excellent burglar alarms. Originally from Africa, guinea fowl were first domesticated by the Romans and are now farmed worldwide for their meat, eggs and feathers. They are ground-nesting birds and scratch out a hollow in the ground in which to lay their eggs. The chicks are known as keets, and their wings grow rapidly after hatching, enabling them to flutter onto low branches at just one week old. Guinea mothers are somewhat unreliable and it is not uncommon for them to abandon their nest for no apparent reason.

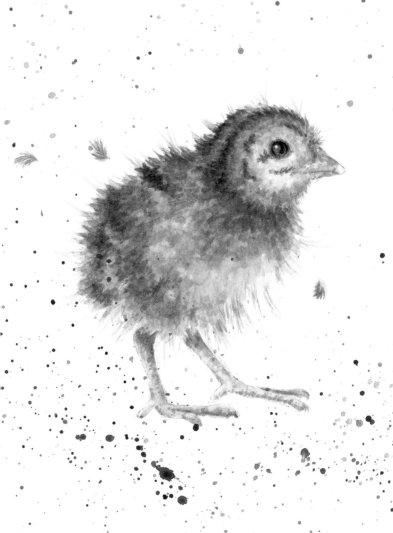

River and Pond

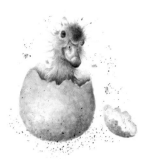

Mallard
Anas platyrhynchos

'Location, location, location' is the order of the day when it comes to mallard nest building. Once mating is out of the way, the male leaves the business of nesting, incubation and rearing of chicks to the female. She chooses a spot on the ground, on dry land but close to water, with overhanging vegetation for some protection. Once a suitable place has been found, the female opts for an efficient nest building method, and rather than bringing material to the nest, relies on what she can reach from the nest itself. Mallards usually lay between eight and thirteen blue-green eggs, and once incubation starts, she will also pluck some feathers with which to line the nest and keep the eggs warm. The eggs hatch after 23–30 days and the ducklings are able to swim from birth and are ready to venture out of the nest after just thirteen hours.

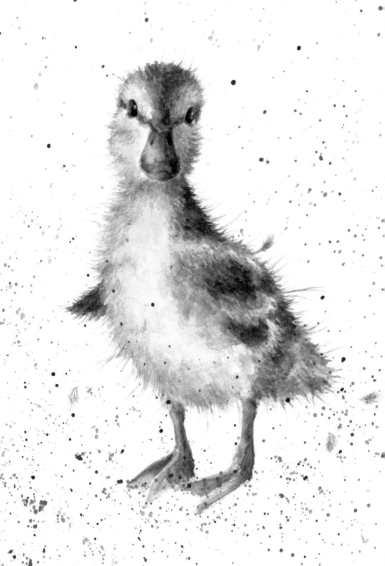

Moorhen
Gallinula chloropus

The appealing moorhen is normally a sociable bird, but the breeding season tends to bring out their darker side, and they become much more aggressive. This leads to squabbling over breeding sites and also equips them to defend their brood from predators – a necessary evil as moorhens aren't too good at picking predator-proof nesting sites. They build a basket-shaped nest on the ground in dense vegetation, and the female lays around seven eggs. When the young hatch, they are soon independent and will be able to leave the nest and feed themselves within a couple of days. The moorhen chicks are adorably comical with their enormous feet, which enable them to walk across clumps of floating vegetation. They also have a rather surprising talent for climbing as they are born with spurs on their wings, allowing them to clamber in and out of the nest. If they feel threatened by a predator, the chicks will cling to the parents who will sometimes fly away from the danger, carrying the young with them.

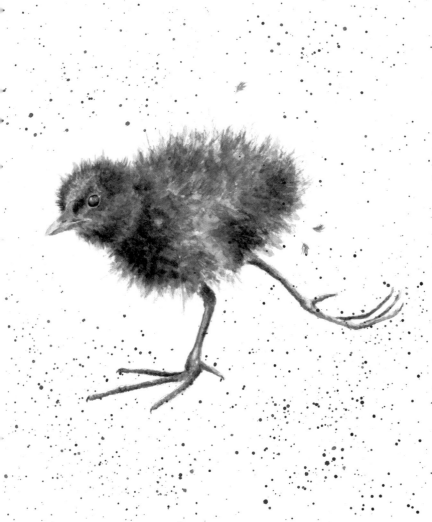

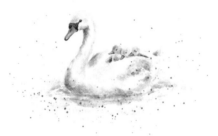

Mute Swan
Cygnus olor

Often seen as a symbol of love, graceful white swans mate for
life, building a huge nest of sticks and grass up to three metres
in diameter at the water's edge. They make a great team with the
male providing the material, while the industrious female builds
the nest. She lays up to seven eggs in April or May, and both the
male and female take turns to incubate the eggs. They hatch after
just over a month. It's hard to believe that the fluffy grey cygnet's
biggest claim to fame is as the star of the book *The Ugly Duckling*
by Hans Christian Andersen. The little bundles of cuteness stay
with their parents for four to five months. Once they have all of their
white plumage, the parents will sometimes drive the young off their
territory, but more often they join their parents on the journey to the
wintering area. Swans often return to the same nest year after year,
repairing any damage before they start all over again.

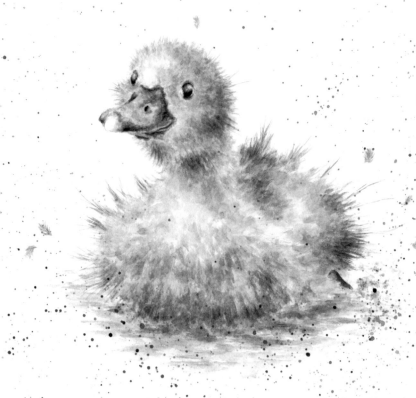

Grey Heron
Ardea cinerea

The majestic heron nests in a suitably grand situation, high amongst
the tops of tall trees near water. They nest in a colony, or heronry,
and the huge bundles of sticks and twigs that constitute their nests
make a striking sight. The male defends his territory fiercely against
other males, fluffing out his feathers and stretching his neck to
make himself as big as possible, while furiously snapping his beak.
If this doesn't deter his rivals then he lunges at them aggressively.
The female heron builds the nest and they will use the same year
year after year, often adding to it so that after a few years it can
be several feet in diameter. She lays four or five eggs at the end of
March and both parents share the incubation. The chicks are noisy
and comical-looking with an eccentric crest perching on top of their
heads. The devoted parents can fly up to 30km from the nest to find
a good hunting ground from which to feed their hungry chicks,
regurgitating a tasty meal when they return.

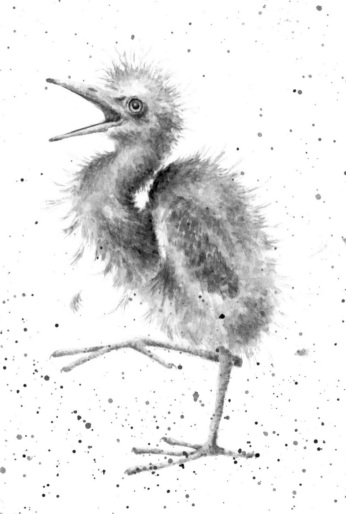

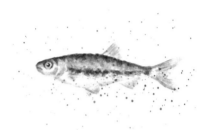

Kingfisher
Alcedo atthis

These busy little birds begin the ritual of parenthood by excavating a deep burrow in a vertical stream bank. The tunnel can be up to 90cm long with a small diameter of 6cm, just wide enough for the kingfisher to squeeze through. The chamber at the end has a slight depression to stop the eggs from rolling out. Six or seven eggs are laid in the nest, hatching after around 21 days. Each chick can eat up to eighteen fish a day, keeping the parents very busy. Kingfisher chicks are nothing if not polite, and they take turns to be fed, moving to the back of the nest once they have had their fish to let others have a feed. They are only fed by the parents for four days once they have left the nest before being driven out of the territory and the tireless birds embark on another brood, often rearing two or three in quick succession.

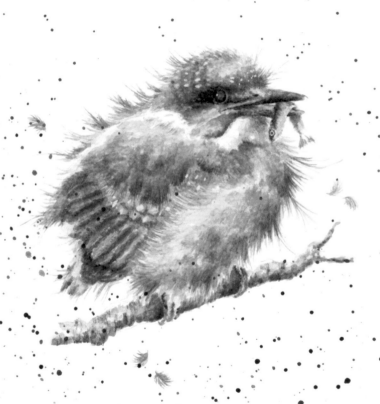

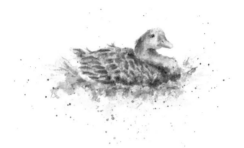

Greylag Goose
Anser anser

The greylag is native to Britain and is the ancestor of most breeds of domestic geese. They breed from early April through to May, and build a large nest in patches of floating vegetation, or nestled amongst the reed beds. The female will lay between five and eight large white eggs, which hatch after around 28 days. Unusual for waterfowl, the gander stays with the family and while the female incubates the eggs, he offers them protection. Both parents have a hand in rearing the young. They all remain together until they join a migratory flock ready for their long overwintering journey.

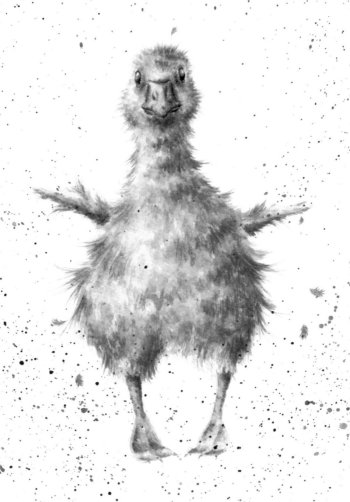

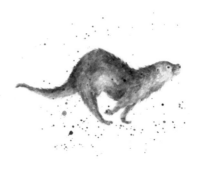

Otter
Lutra lutra

Otters are well known, and loved, for their playful nature. Their courtship routine is no exception, with the prospective parents darting and diving through the water, playfully biting one another on the nose as a sign of interest. The otter pups are born blind and helpless, deep within their underground den. Otter mothers spend up to eight hours a day nursing their young. She has no help from the father in rearing the pups, but they remain on his territory and gain some protection from this. At two months, the pups' coats are waterproof enough for them to venture into the water, and the mother will spend much of her time playing with the young, of whom she remains highly protective, teaching them important skills. With such devoted care, it is no wonder that a high proportion of otter pups survive their first year of life.

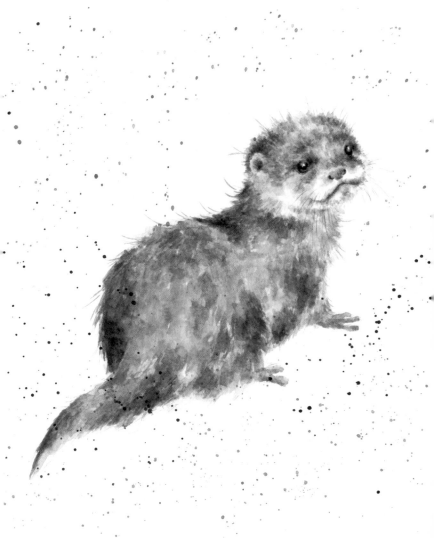

Coast and Sea

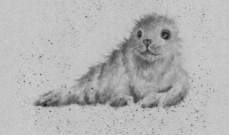

Puffin
Fratercula arctica

As if they weren't cute enough already, puffin chicks are adorably known as 'pufflings'. The adults, who spend most of the year out on the open ocean, return to land between April and August for the breeding season. Puffins mate for life, and it is thought that the brighter and more colourful a puffin's beak and feet, the more attractive it is to the opposite sex. They excavate a burrow in the cliffside around 90cm long and build a nest at the end, in which a single egg is laid. Both parents take turns to incubate the egg, and when the puffling emerges, around 40 days later, both mum and dad do their share of feeding. It is common to see puffins returning to the burrow with their colourful bills full of fish, ready to feed their rapidly growing offspring. The young chick remains in the burrow until it is able to fly.

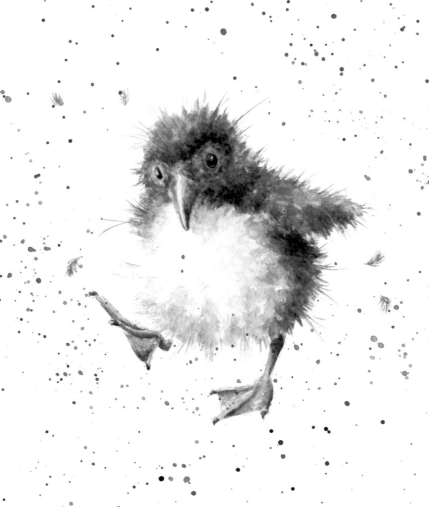

Grey Seal
Halichoerus grypus

In Britain, grey seal pups are born along the Atlantic coast from
September to November. They are covered in a dense, soft and silky
white fur, and already weigh an impressive 14kg at birth. They are
cared for by their mother for a relatively short length of time, but
the milk's quality more than makes up for the lack of quantity.
The milk she feeds her pup is very rich, with around 60 per cent fat
content, and by the time she has finished weaning the pup, its weight
will have increased fourfold. After fifteen to twenty days the mother
will finish feeding her baby and leave it to fend for itself. The pup
then relies on its fat resources, often fasting for up to four weeks
before it learns to catch fish. The mother returns to the sea to once
again find a mate, and the story begins all over again.

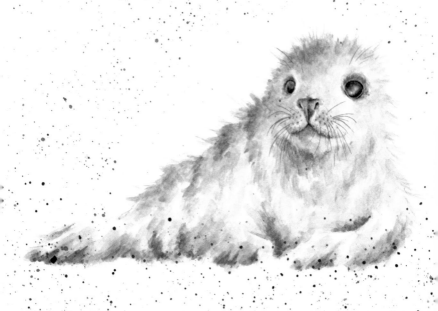

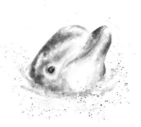

Bottlenose Dolphin
Tursiops truncatus

The much-loved and highly intelligent bottlenose dolphin is not a fish but a mammal and must surface regularly to breathe. In fact, as dolphins aren't involuntary breathers like us humans, they can't fully sleep – one side of the brain must remain awake so that they remember to breathe. Once they reach maturity, dolphins breed year round. At nine weeks, ultrasound scans have revealed that the dolphin foetus has already started swimming. The developing calf also has a pair of rear limbs, a throwback to its evolutionary history, which disappear before birth – these are thought to suggest that dolphins evolved from land mammals. After twelve months, the baby is born in the water and swims to the surface to take its first breath. It is nursed for twelve to eighteen months but remains in its mother's care for three to six years. Dolphins are very sociable animals, living in large groups, and the mother often receives help from other dolphins in rearing her calf.

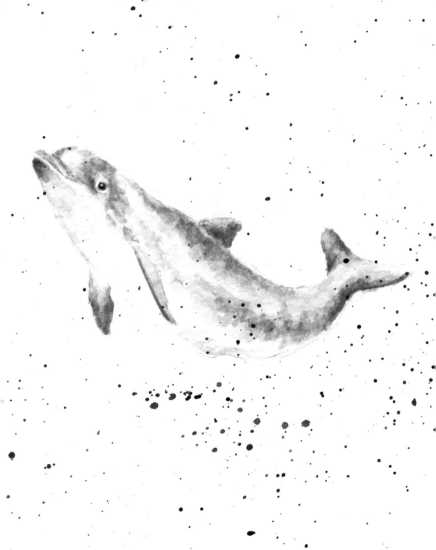

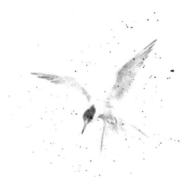

Common Tern
Sterna hirundo

The so-called 'swallow of the sea' is a handsome bird, with a black-capped head and forked tail. It is commonly seen hovering gracefully, before diving with remarkable speed into the sea to catch a fish. Opting for 'safety in numbers', common terns breed in noisy, chattering colonies. At the start of the breeding season, these curious birds engage in a strange behaviour known as 'dreading', where the entire colony silently flies out to sea, low and fast. Although it sometimes occurs in response to a disturbance, at other times it appears to happen at random. Tern courtship consists of elaborate aerial displays. Once a mate has been found, the male and female embark on selecting a nesting site – they may investigate several spots before settling on 'the one', when the female lays three speckled eggs. In colonies often consisting of thousands of nests, common terns have the remarkable ability to locate their nest – even if nest material has been moved or the sand smoothed over. Both parents incubate the eggs, which hatch after around 22 days.

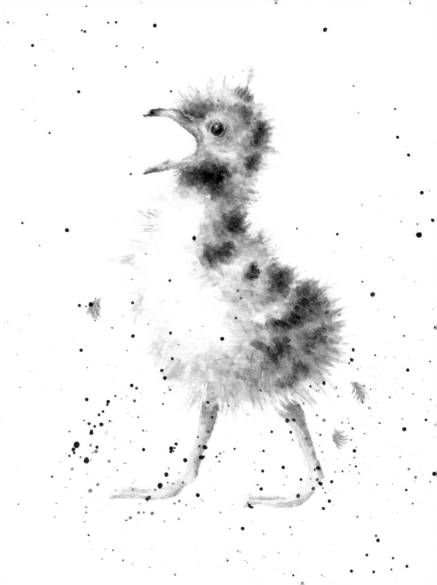

Garden and Meadow

Robin
Erithacus rubecula

The robin is one of the most iconic and well-loved of all garden birds. They start their noisy courtship songs as early as January and as the mating season hots up, the male robin courts the female, bringing her gifts of worms and caterpillars. She flirts back noisily, fluffing up her feathers and hungrily accepting the offered food – the ritual is often mistaken for a parent feeding a chick. When the eggs are laid, the female takes on all of the responsibility of incubating them, while the dutiful male brings her food up to three times an hour. She is very skittish and will often desert the nest if she is disturbed for fear of predators, even after the eggs have been laid. When the eggs hatch, both parents help to feed them until they fledge at around two weeks. If they have had an early brood, the pair may have a second or even a third brood in a year, but once the season is over, they will look for a new mate the following year. The parental instincts are strong in robins and, endearingly, they will often feed the chicks or fledglings of other bird species.

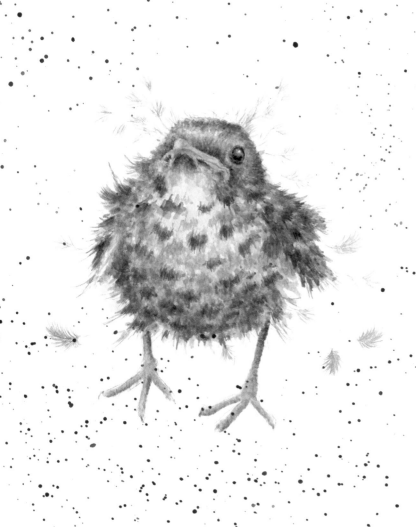

Blue Tit
Cyanistes caeruleus

Blue tits really love caterpillars. They love them so much that caterpillar abundance is the main factor determining the number of eggs laid in a particular year, the timing of egg-laying and even the likelihood of the chicks to survive. A single chick can eat 100 caterpillars a day, and as blue tits can have up to thirteen chicks in a brood, that is a lot of caterpillars! The eggs are laid in a neat, cup-shaped nest lined with hair, feathers and wool. The female does the majority of the nest building, creating a bald patch on her chest known as a 'brood patch', where she plucks out feathers to line the nest. The female incubates the chicks for twelve to sixteen days, while the male fetches her favourite food... caterpillars! Both parents will feed the chicks, and they fledge after nineteen days.

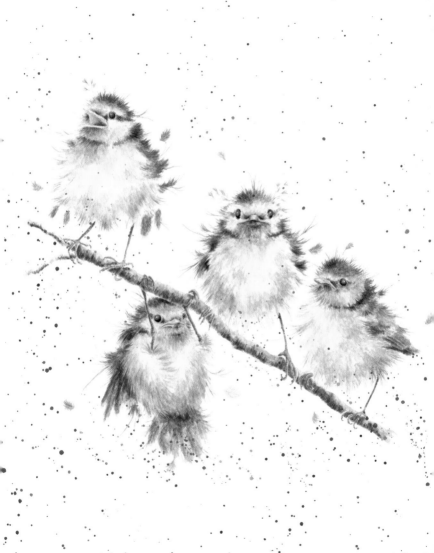

Blackbird
Turdus merula

The wonderfully vocal blackbird is a popular and welcome visitor to our gardens. The breeding season kicks off in March with the male stretching his vocal chords, defending his territory from other males and trying to attract females. He also performs a courtship dance for his mate. Pairs tend to be monogamous, often staying together for subsequent years. The female builds the nest and lays three to five pretty blue, speckled eggs. For all of the blackbird's good points, hiding their nests is not one of them and they often suffer from predation. We have barely scratched the surface of understanding the blackbird's complex vocalisation – it is thought that a female can communicate to her chicks whether a potential threat is on the ground or in the air, and the chicks react accordingly.

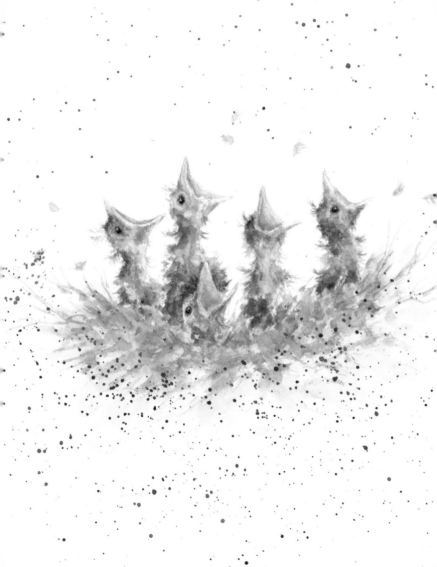

Song Thrush
Turdus philomelos

Song thrushes are amongst the most vocal of our garden birds when it comes to reproducing. The breeding season starts in March, when the male has established his territory and begins to sing his beautiful melodies in the hope of attracting a mate and to defend his territory. With around 100 different distinguishable phrases, the song thrush is a prominent member of the dawn chorus. While the male sings his heart out, the female is busy building a neat, cup-shaped nest, lined with mud. Thrushes often produce two to three broods each season, which lasts until August, each with three to five eggs. The female incubates her eggs, and both parents feed the young in the nest. Once the chicks have fledged, the male does much of the babysitting while the female begins to prepare for the next brood. Young thrushes can often be seen playing with, and flicking, small objects as they try to learn the vital survival skill of breaking open snail shells with stones as tools.

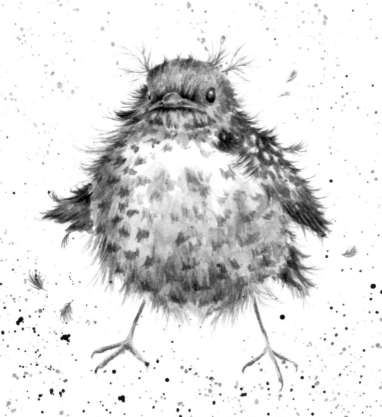

Buzzard
Buteo buteo

Buzzard courtship has to be amongst the most impressive in the British countryside, with the male performing what is known as the 'rollercoaster flight'. He soars up into the sky and then comes plummeting down, twisting and spiralling as he falls, then repeats the whole performance over and over again. He is no doubt relieved that once he has found a female suitably impressed by his display, they will mate for life. Buzzards are strongly territorial and can have up to fourteen potential nest sites on their territory, alternating which one they use each year. They build a nest from twigs and line it with soft materials and, having a flair for interior design, buzzard nests are often decorated with green foliage. In April or May, the female lays two to three eggs. Both male and female take turns to incubate the eggs and also to feed the chicks once they hatch. Buzzards are strongly maternal and there are even stories of captive females rearing broods of hen chicks!

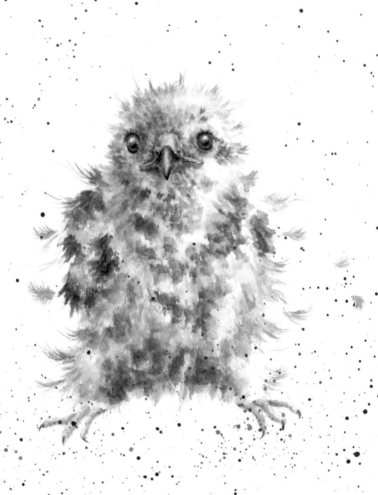

Barn Swallow
Hirundo rustica

British swallows spend the cold winter in South Africa, returning
to Britain in April and May when the breeding season begins. The
male selects the nesting site and then advertises it to the female
with a wonderful display of swooping flight and loud calls. Once
paired, swallows will mate for life – although the hapless males are
often cuckolded by the flighty females who are thought to prefer
males with long tail feathers. The nests are almost exclusively built
on man-made structures, and when the site has been chosen, both
parents set to work building a cup-shaped nest from mud mixed
with soft material, such as grass. The female lays an average of five
eggs, which hatch after around two weeks. The chicks remain in the
nest for another three weeks, but begin to practice stretching their
small wings at nine days, getting ready for their first flight.

As they don't nest in trees, where leaves and branches could
break a fall, swallow fledglings have to be ready for a smooth take-
off on the first attempt!

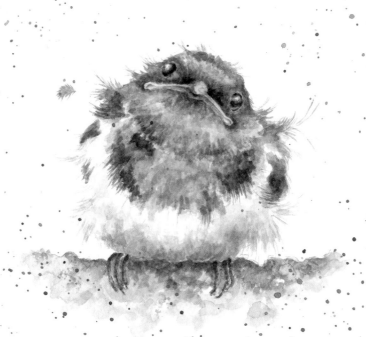

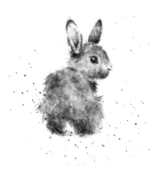

Rabbit
Oryctolagus cuniculus

It's no wonder that rabbits are notorious for their prolific reproduction capabilities – they can start breeding at just three or four months old, giving birth to between three and eight babies, or kits, after 31 days, and can then go on to breed another three times each year. The kits are born, naked and blind, in a nest below ground. Their eyes open between ten and fourteen days old. Rabbits have often been mistaken for neglectful mothers, as they leave the kits on their own the majority of the time, only returning to feed them for five minutes each day. However, the milk is so rich that it can sustain them for up to 24 hours, and the mother's apparent neglect is actually a ploy to try and keep them safe – constantly returning to feed them would just attract the attention of predators.

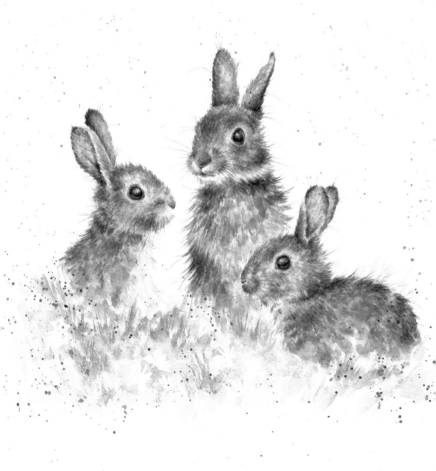

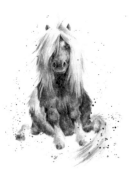

Shetland Pony
Equus ferus caballus

As the name would suggest, the Shetland pony hails from the Shetland Isles just off the coast of Scotland, and it is thought that their ancestors lived on the Islands as far back as the Bronze Age. The harsh climate and scarce food have fashioned a tough little pony, famous for its diminutive stature, but strong and intelligent as well. In fact, the little Shetland is the strongest of all horses, pound for pound, and it can pull twice its own weight. In the industrial revolution, this versatile little pony helped miners in the coal mines and the famous pit ponies are remembered for their bravery in these tough conditions. Testament to their intelligence, miniature Shetlands are even used as guide horses, helping the blind in the same role as guide dogs. It's hard to imagine a more appealing creature than a Shetland foal, standing within minutes of birth and clothed in a tufty, warm coat, already well-equipped to cope with the difficult conditions of its ancestral birthplace.

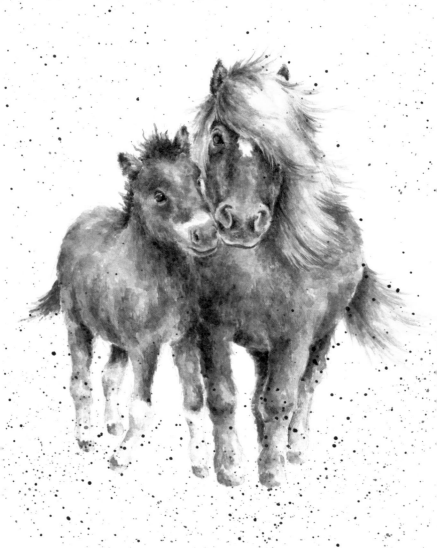

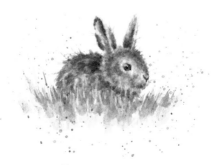

Brown Hare
Lepus europaeus

The breeding season for hares stretches from January to August and competition between suitors is fierce, resulting in the eccentric courtship displays that the 'mad March hares' are famed for. When the female is ready to mate, she darts off, starting a chase across the fields intended to test the fitness of the pursuing males. Only the fittest get to mate, ensuring that her offspring inherit the very best genes. Unlike their rabbit cousins, baby hares, or 'leverets', are born in a hollow nest in open ground. Without the protection of an underground burrow, the young are born with a full fur coat and open eyes. The mother hides the young in their nests and returns to feed them for only five minutes a day, but her rich milk sustains them all day. They are independent soon after birth and fully weaned after a month.

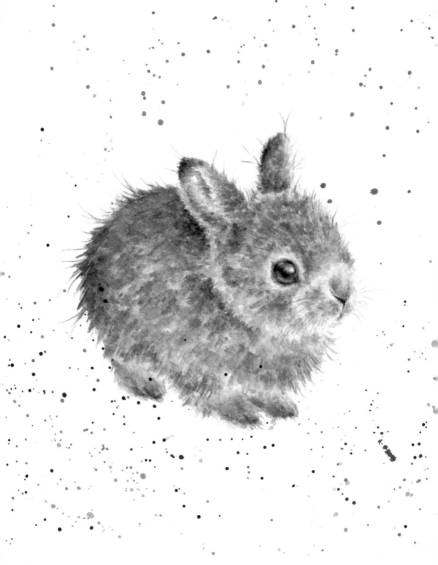

Wood Mouse
Apodemus sylvaticus

Loved or loathed, it's hard to deny the cuteness of one of our most common mammals. The busy little wood mouse usually only lives to see one breeding season, so they have to make it count. The breeding season spans from February to October and the female mates with numerous males for each litter she produces. She digs an underground network of burrows and gives birth to an average of five mouse pups in a nest chamber lined with leaves, moss and grass. The pups are born blind and helpless but develop quickly. At three weeks, their mother ushers them out of the nest and they are on their own, while she begins to prepare for her next litter.

Domestic

Domestic Tabby Cat
Felis catus

Although not a distinct breed, the 'moggy' is by far the most popular type of domestic cat and comes in all sorts of shapes and sizes. The beautiful tabby markings are found on many different breeds and consist of distinctive swirls and stripes – always with a 'M' shape on the forehead. The human love affair with cats started around 10,000 years ago when we first started to domesticate them and they have become a much-loved member of millions of families across the world. Cats are prolific breeders, producing between one and eight kittens per litter, and up to three litters a year. An average female can produce over 100 kittens in a lifetime. Before she gives birth, the female becomes restless, seeking a nest in a quiet, warm and dark spot. The kittens are born blind and deaf, with their eyesight and hearing developing within two weeks. The collective noun for kittens is a 'kindle'.

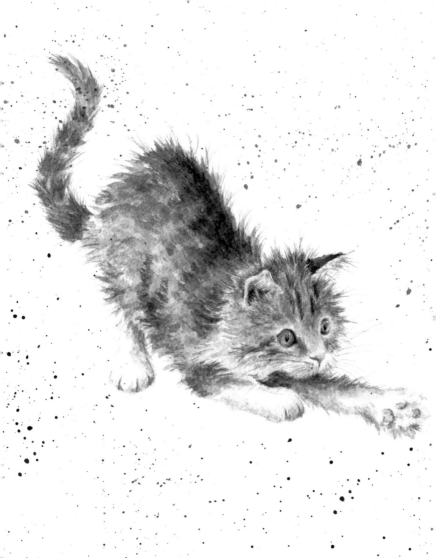

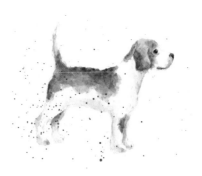

Beagle
Canis lupus familiaris

With its smooth, richly coloured coat and long, silky ears, beagles
are utterly handsome dogs. They must have a white-tipped tail
or they are not classed as a true beagle. Beagles were originally
bred in England for hunting hare, fish and game birds, but the
earliest breed was much smaller than the version we know and
love today. Known as a 'pocket beagle', it was small enough to fit
in a pocket or saddlebag – in fact, the name Beagle is thought to
derive from the Celtic word 'beag', meaning small. Beagle pups are
gentle and playful, but also protective and fairly sturdy,
making wonderful family pets. They are true pack animals and
are always happiest with other dogs or their human pack
members. Beagles have an extraordinary sense of smell, having
220 million scent receptors, putting humans to shame with our mere
five million. The most famous beagle of all, immortalised in the
Peanuts comic strip, is of course the adorable Snoopy.

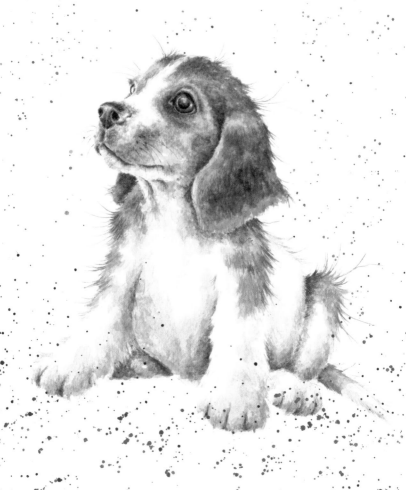

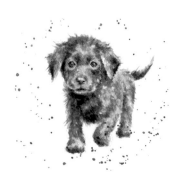

Labrador
Canis lupus familiaris

The lovable labrador is by far our most popular breed of dog, and no wonder – warm, intelligent and loyal, they make wonderful family pets and loving companions. Labrador puppies are lively bundles of fun and love to play. They are very bright and quickly respond to training. They also love their food and are not usually known as fussy eaters! Labs can be black, yellow or chocolate, and more recently, other colours such as silver, white and fox red have also started to appear – although these are really just variations of the main three colours. Labradors were originally bred in Canada as companions and helpers to fishermen. Amazingly, they were almost on the verge of extinction when they were first brought to England as a hunting dog in the 1800s. Their fate was soon secured as they won a place in our hearts with their gentle and friendly characters.

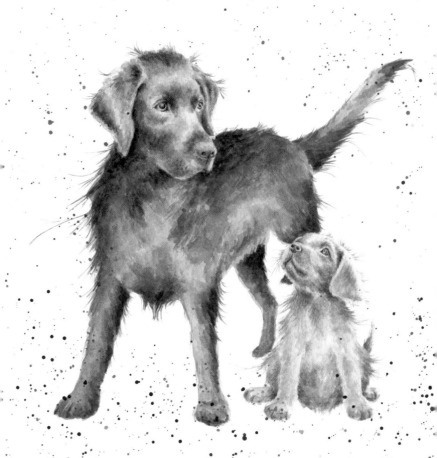

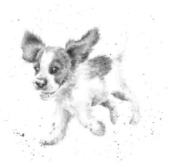

Spaniel
Canis lupus familiaris

Enthusiastic tail wagging is the signature style of spaniels, as any spaniel lover well knows. Affectionate, patient, playful and adaptable, there are eighteen breeds of spaniel across the world, the most well known being the springer spaniels, the cocker spaniels, the water spaniels and the cavalier King Charles spaniel. It is often thought that they originated in Spain ('spaniel' deriving from the Latin for 'Spanish') but this is widely questioned and there are many theories as to their origin. Spaniels were originally bred as hunting dogs, flushing (or springing!) game out of dense patches of undergrowth. Their intelligent and gentle nature, as well as their fun-loving and playful personalities, makes them an ideal family pet and there is no wonder that their popularity has soared. Spaniel puppies are energetic bundles of fun, needing large amounts of attention and exercise. They are devoted to their human families and will want as much company as possible!

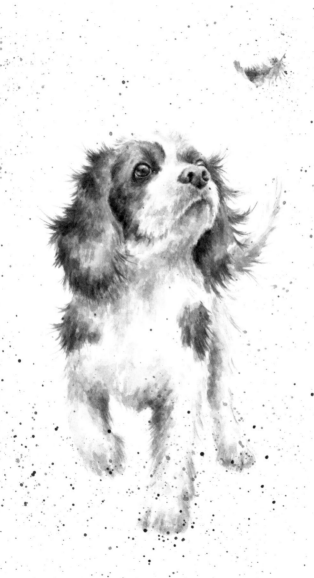

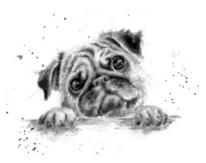

Pug
Canis lupus familiaris

What's not to love about an animal whose collective noun is a 'grumble'? With their wrinkly faces and intense loyalty, pugs are amongst the most-loved dogs worldwide. They are thought to be the oldest breed of dog and were originally bred to sit in the laps of Chinese emperors. It is thought that their wrinkled faces were highly valued because the flaps of skin formed the shapes of Chinese characters. Unlike some of their more energetic cousins, pugs like their rest and sleep for up to fourteen hours a day but don't be fooled into thinking that pug puppies are equally as docile – they enjoy tearing around, nipping, chewing and creating as much general mayhem as any other self-respecting puppy. They have been bred as companions and, as such, love human company – almost as much as they love food. A pug pup will pretty much have a go at eating anything, regardless of whether it is generally considered 'edible'.

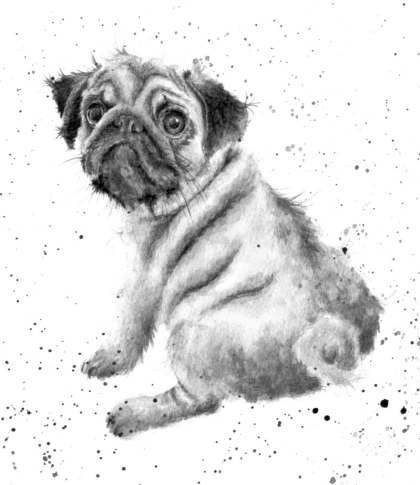

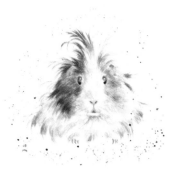

Guinea Pig
Cavia porcellus

The guinea pig hails all the way from the South American Andes, and has become one of the most popular pets in the United Kingdom. Friendly, sociable, and utterly cute, guinea pigs make excellent pets. If given the opportunity, they are prolific breeders and can produce up to five litters a year, each with up to four young after a 70-day gestation. However, pregnancy is very hard on guinea pig mothers, and she can double her weight during pregnancy. No wonder, as the young are born large, fully furred and ready to go – they are independent after just five days.

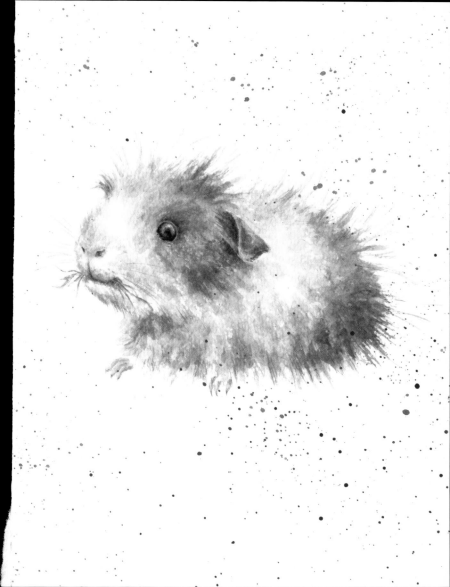

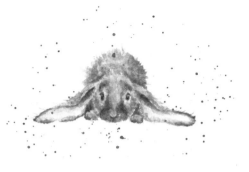

English Lop
Oryctolagus cuniculus

With typical English eccentricity, this breed of rabbit has the
floppiest, loppiest ears of all. Developed in the nineteenth century
when the Victorians adopted the rabbit as a mainstream household
pet, the English Lop is thought to be one of the oldest breeds of
domestic rabbit. Placid and docile to the point of being lazy, curious
and friendly, the English lop is most famous for its distinctively long
ears and large size. It is a prolific breeder with a strong maternal
instinct and rich milk to nourish its young. The kits are born
with normal sized ears, but for the first four weeks of life, they
double in length and at four weeks old, the ears are longer than the
body, providing a logistical challenge for the young rabbits when
negotiating the world around them.

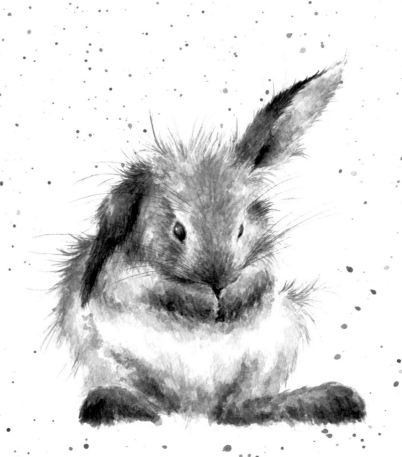

Thoroughbred
Equus ferus caballus

Hot-blooded, alert, courageous, racy and nervous; the thoroughbred name has become synonymous with anything highly-strung, well-bred and magnificent, but it actually refers to a specific breed of horse. All thoroughbreds descend from three stallions that were bred with English racing mares in the seventeenth century, and gave birth to the first thoroughbred foals. Famous for their elegant profile and long, powerful legs, thoroughbreds can reach speeds of almost 40 miles per hour, making them the first choice for racehorses. Regardless of when they are actually born, all thoroughbred foals have an official birthday on the 1st January – what a party in the stables that night…

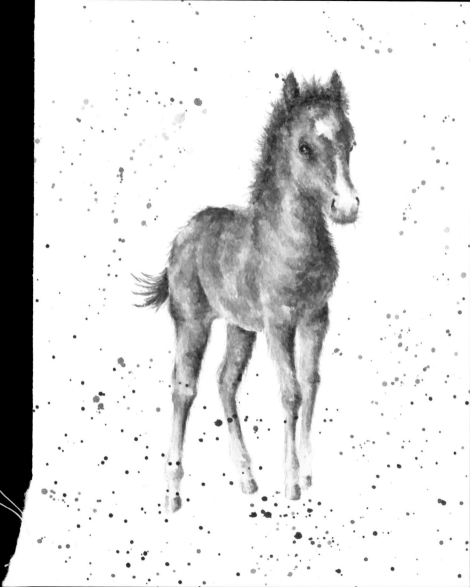

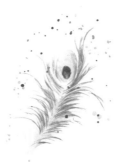

Peacock
Pavo cristatus

The most extravagant and showy of birds, the peacock has
long been prized for its handsome looks and eccentric displays,
historically found strutting around country homes and estates as
a symbol of status. Fittingly for a bird so colourful and vibrant,
the collective name for a group of peacocks is a 'party'. Although
known generally as peacocks, the name is only actually correct
for the male – they are really peafowl, the females are known as
peahens, and adorably, the young are peachicks. They are social
birds and when it comes to breeding, the males really come into
their own, strutting around and displaying their magnificent
tails to prospective mates. The most successful males have a
harem of females who nest in a shallow scrape on the ground,
laying a clutch of three to five eggs. The chicks hatch after 28
days, not yet displaying the colourful plumage of the adults,
but attractive nonetheless. They are relatively independent after
birth and need little assistance after a day or so.

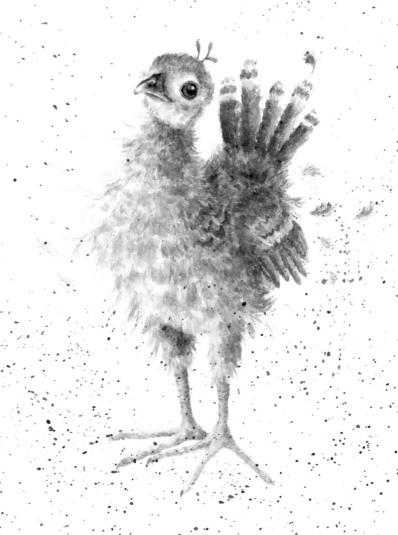

Index